HACKNEY LIBRARY SERVICES

Please return this book to any library in Hackney, on or
before the last date stamped. Fines may be charged if it is late.
Avoid fines by renewing the book (subject to it NOT being reserved).

Call the renewals line on 020 8356 2539

People who are over 60, under 18 or registered disabled
are not charged fines.

Cls/

⊕ Hackney

PJ42014

DRAWINGS

DRAWINGS
STEPHEN WILTSHIRE

Selected and with an Introduction by
SIR HUGH CASSON

Foreword by
LORRAINE COLE

J.M. DENT & SONS LTD
London & Melbourne

First published in Great Britain in 1987
Illustrations copyright © Stephen Wiltshire 1987
Text copyright © J.M. Dent & Sons Ltd 1987

Printed and bound in Great Britain by Billing & Sons Limited, Worcester, for
J. M. Dent & Sons Ltd
Aldine House
33 Welbeck Street
London W1M 8LX

British Library Cataloguing in Publication Data

Wiltshire, Stephen
Drawings.
1. Children's art 2. Buildings in art
3. Autistic children
I. Title 11. Casson, *Sir* Hugh
741.942 N352

ISBN 0–460–04751–5

INTRODUCTION
by Sir Hugh Casson

Those of us who say 'I wish I could draw' always forget that once upon a time they could draw and did draw – unselfconsciously and with pleasure if not always very well. All children indeed enjoy drawing. They find it more fun than writing and the quickest way they have of getting the message across. (No wonder so many artists from Goethe to Picasso have written enviously of that innocent eye.) It can, however, be a fugitive talent, dying early of neglect or killed off by competing interests and educational pressures. Happily, every now and then, a rocket of young talent explodes and continues to shower us with its sparks. Stephen Wiltshire – who was born with severe speech difficulties – is one of those rockets. A natural gift for drawing was unearthed by his teachers and nourished until it became not so much the medium as the message itself – a passionate and personal form of communication.

Unlike most children, who tend to draw less from direct observation than from symbols or images seen second-hand, Stephen Wiltshire draws exactly what he sees – no more, no less. He stands before the object – usually a building – for, say, fifteen minutes, seeming to watch it rather than to observe it. Later he will draw it, quickly, confidently and with an accuracy all the more uncanny because it is done entirely from memory and without notes. He misses no detail – nothing. The only 'inaccuracy' is that the object in his drawing is 'mirrored'. His preferred subject is always architecture and the pricklier and more compli-cated the better. He treats it as a scenery of patterns rather than as spaces concealed, but his sense of perspective is sure and the Albert Hall (p.6) is unmistakably round.

To watch him draw is an extraordinary experience. Where he starts on the paper seems capricious and to him unimportant. He may begin at the top, the bottom or in the middle, with the pavement, the roofline or a window. From the first mark the pencil moves as quickly and surely as a sewing-machine – the line spinning from the pencil point like embroidery. Suddenly it is finished. He is satisfied and will wander off to look out of the window.

It is a moving and so far a triumphant story. The life of an unusual child – lonely because in his earliest years speechless – has been transformed by the way that his natural skill as an artist has been extracted, as it were, and developed with the loving and patient help of his family and teachers. He draws now with increasing confidence and sharper self-criticism. He looks for harder problems and new challenges, although still fascinated by buildings more than by other subjects.

Now that he can read and write will this extraordinary vision and talent develop further or will it disappear? Not even the experts can tell us. For the moment it continues to enrich his life beyond measure. To achieve is always to enjoy and Stephen enjoys drawing above all else and, as the following pages will show, he manages to convey that enjoyment to all of us. Lucky Stephen, can one say? Perhaps – but certainly lucky us.

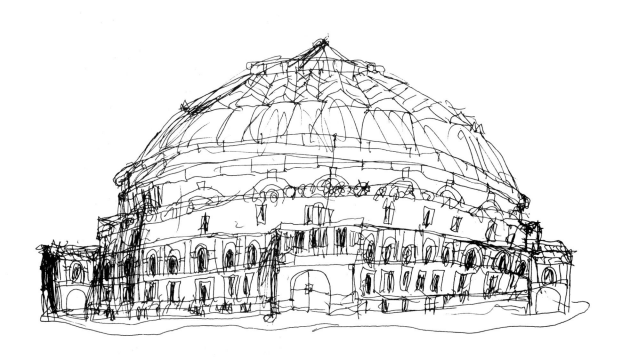

The Royal Albert Hall

FOREWORD
by Lorraine Cole

*Lorraine Cole is the headmistress of the ILEA school
Stephen attended from January 1979 to July 1987.*

The vast majority of us learn to talk. Language makes it possible for us to make our feelings and our needs known to other people. We think with it, can play with it and we can ask the questions that help us make sense of our experiences. We are usually so comfortable with it that we take it entirely for granted that our children will acquire the same skill. A few children, for reasons not yet fully understood, do not do so and remain lost and speechless in a language-dependent society.

Stephen was one of these children. When he started at school at the age of four years he was totally withdrawn and almost mute. He seemed unaware of other people, made no eye contact and roamed about aimlessly making sudden dashes to other rooms where he would stare intently at pictures which fascinated him and bolt back to his classroom. He showed no interest in any of the activities going on around him in his classroom. He would co-operate in a mechanical way when his teacher worked with him individually, but the moment his teacher moved away, Stephen would start his lonely pacing, or find paper and pencil and scribble, totally absorbed for long periods. Many of his drawings, as a result, are on scraps of paper.

The teachers who work with these complex children are skilled at making good use of whatever the child offers and Stephen's one interest was clear.

Step by step Stephen was encouraged to draw and to use his drawings as a way to communicate something of his inner world. The speech therapist and teacher worked closely together in helping Stephen master the words that he needed most and were rewarded when one day Stephen said, 'Paper?' At that point we knew that he was beginning to understand how useful speech can be and we made sure that every spoken request he made was met with very quickly. Word by word, and over a long period of time, Stephen began to build up his vocabulary. He was encouraged to talk about his pictures and began to

take pleasure in his growing skill. His drawings improved rapidly and he experimented with a wide range of materials and techniques, startling us one day with a series of wickedly accurate caricatures of members of staff, and laughing very loudly at the effect they produced. We now knew that despite his apparent disinterest he was observing us very closely indeed.

Events began to speed up. Stephen learned to read and became able to use the library and choose for himself books on architecture and travel. He joined in drama sessions and proved to be an excellent mime artist. His portrayal of an angry man in a restaurant was so spirited and so funny that it was only when we played back the video we had made that we realized he had used no actual words, only a wide range of angry noises. It was then that we understood his capacity for imitating sounds. He surprised us again when children were being noisy outside the speech therapy room where Stephen was working. He stood up suddenly and said, 'Leave this to me,' left the room, roared at the offending children, 'Be quiet,' returned, sat down and said in gloomy tones, *Pathetic children.'*

Stephen and his family had suffered a great deal when Mr Wiltshire was killed in a road accident. Stephen, who was three at the time and had a close relationship with his father, was deeply shocked and distressed. As he had become able to communicate through his drawings and some language, the team guided by the psychiatrist felt that psychotherapy could help him. It has been a regular and important part of his life since then.

When the question of his appearance on the BBC TV programme QED was first proposed we were concerned as to whether such exposure could harm Stephen or his family in any way. We were reassured by the sensitive way in which the whole matter was handled and by Stephen's mother's pleasure at the recognition of her son's amazing gift. Stephen himself was keenly interested. We took him to see some buildings he had not drawn before and asked him to draw them from memory as he would be required to do for the cameras. We wanted to be sure that he understood what was being asked of him. As we explained he nodded gravely and said, 'Oh yes, yes.'

We chose St Pancras Station for the programme because it is a very 'Stephen' building, elaborate, detailed and incredibly complicated. The very sort of challenge that Stephen enjoys.

We all felt anxious on the day but Stephen patently did not. He displayed an impressive sense of occasion and took upon himself the role of tour guide for the

camera crew pointing out buildings as they drove to the station as well as makes of cars for good measure. He ate lunch in his usual calm fashion, went out to play and then quietly executed his lovely drawing with total self-assurance, even getting the hands of the clock exactly where they had been when he saw them, twenty past eleven.

When the programme was shown in February 1987, Stephen was excited and found it hard to wait until he saw himself. He watched intently and then said quietly to himself, 'That's good.'

Some children, with similar difficulties to Stephen, lose the drive to draw when other forms of communication open up for them. Stephen continues to draw and gives himself artistic problems to solve. He is critical of his own work and rejects drawings which do not meet his own exacting standards saying, 'No good at all.' He pores over aerial photographs of London at the moment, seeming to be working out problems of perspective with astonishing concentration, even, on one occasion, surrounded by children playing instruments. Stephen remained totally immersed in his study of his book, small, hunched and pre-occupied.

Although language remains very difficult for him and is sometimes only grudgingly offered, he has continued to change, show his sense of humour and make more real contact with people. His delight in drawing continues to enrich not only his life, but other people's, and Stephen himself put the seal on it all when he managed to say, 'I'm glad they like my drawings.'

Stephen is about to move to his secondary school. All parents and children find this an anxious time but Stephen seems very composed and calm about the whole matter. When he visited the school he made a bee-line for the library, selected books with his usual care and studied them intently looking for good pictures of buildings. He tells us that he liked the school and is pleased to be going there.

He still needs special help but his new school will give him a whole new range of experiences and a wider selection of friends. These days he is so self-possessed that we feel all will be well. Needless to say, we will follow his progress with keen interest.

We will certainly miss Stephen, he has been with us for a long time and we will feel the lack of his gentle personality, humour and curious dignity but, like good parents, a school's job is to help a child become able to manage without us and move on in the world, and that is what Stephen is about to do.

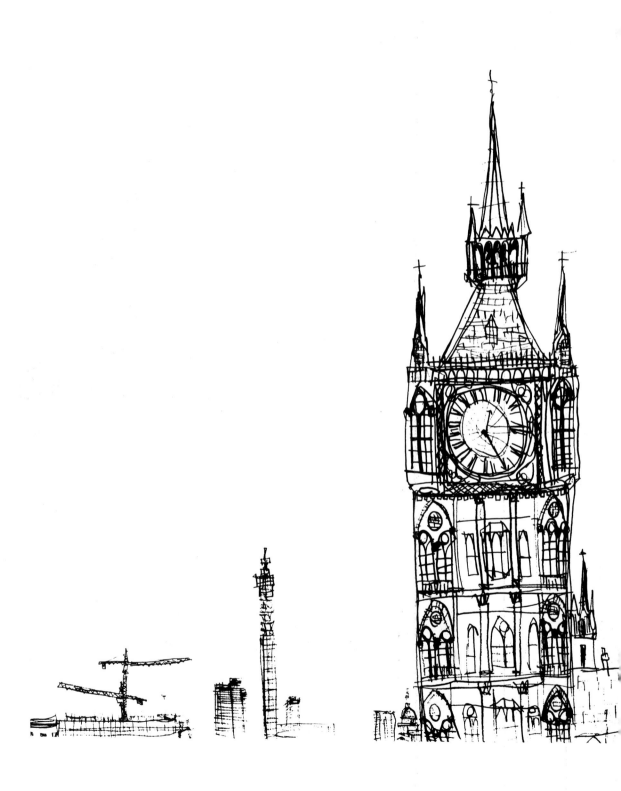

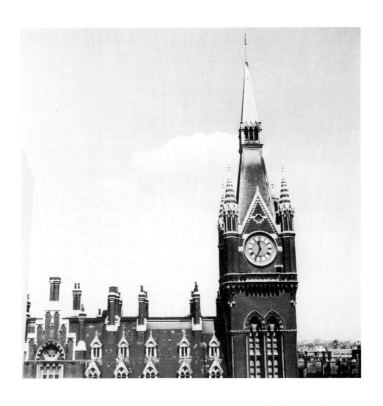

St Pancras Station

A GIFTED AUTISTIC ARTIST

A leading psychologist examines the clinical background to Stephen's case and sums up the current state of research into autism.

The drawings which constitute the material of this book are remarkable by any standard for at least two reasons. One is that they were done very quickly and with an assurance of line which would be the envy of many professional artists, and another reason is that most of them are done from memory. A sophisticated motor skill capable of conveying a visual impression with such remarkable economy and speed requires a psychological quality which is rare in normal people. A memory for scenes, whether these are of a tranquil or busy nature, is also rare. To find two such gifts both present in a normal child might surprise many, but to find them in a child who is badly mentally handicapped as well as autistic is a phenomenon which demands the close attention of all of us and especially of parents, teachers and psychologists.

That such a level of skill can be found in someone so handicapped is a fact which has been observed by psychiatrists and psychologists since about 1825, but apart from recording remarkable cases such as those like Stephen Wiltshire, the artist whose drawings form the bulk of this book, few explanations of the phenomenon have been attempted. Psychologists have recently suggested that gifts of this kind occur predominantly in people who lack the ability to abstract or generalize. This would mean, of course, that one would be unlikely to find a gifted mathematician of low intelligence, although a gift for arithmetical calculation would be a possibility. However, as the present example clearly shows, artistic ability of a high order can occur in the absence of normal intellectual ability.

Stephen, as well as having a low measured intelligence, has also been diagnosed as autistic, that is lacking the normal social skills and insights which make most of us social animals. Autistic children are sometimes said to lack emotional warmth and to treat people, even their mothers, as objects.

The initial definitions of autism placed considerable emphasis on affective and social isolation, although other symptoms such as obsessionality, mutism and pre-occupation with objects were also mentioned. Subsequently emphasis

shifted to the cognitive deficiencies shown by a high proportion of autistic children although their social aloneness or awkwardness was never overlooked. Many studies also drew attention to possible associations between autism and specific neurological problems such as epilepsy. Currently, research has tended to return to a reconsideration of the emotional mal-development characterizing autism, contrasting or comparing such deficiences with the frequently found cognitive deficiencies. Where both emotional indifference or inadequacy and cognitive defect are found together, the extent to which one may be dependent on or independent of the other is frequently a matter for discussion.

The more extreme signs of this indifference are now less marked in Stephen than they were at the time when he was diagnosed and the one obvious remaining indicator of his condition is the marked difference between his linguistic intelligence level and his intellectual level in non-linguistic abilities, a difference, in fact, of some fifteen points of IQ, his verbal intelligence being more handicapped. Otherwise, at the present time Stephen appears to be a reasonably sociable though handicapped lad.

However, even had he shown many more signs of autism than he does at present, these would not in themselves account for his outstanding ability as an artist. One student of autism, for example, has estimated on the basis of questionnaires that just under ten per cent of autistic children can be regarded as gifted, so that although this is a high percentage, not all autistic children are gifted. Nor are all gifted and handicapped children autistic. Another psychologist has estimated that the incidence of giftedness in non-autistic mentally handicapped children is less than one per cent. This is a lower percentage than in autism but, of course, there are many more mentally handicapped children than autistic children, so that the absolute numbers of gifted mentally handicapped and gifted autistic children may not differ very much.

Even so, the high incidence of giftedness in autistic children clearly suggests that there may be some quality characteristic of autism which promotes giftedness. Clinical observation suggests that an obsessional addiction to their chosen topic, art in Stephen's case, may be an important contributing factor, and obsessionality is a quality frequently found in autistic people. Thus it can be that children who are mentally handicapped and also gifted in some way might show some signs of obsessionality, a quality not usually found among the mentally handicapped. In other words, giftedness may be associated with obsessionality rather than necessarily with autism or with mental handicap alone.

Not all gifted but handicapped people are artists, but if we consider only the group of autistic and artistically talented children, a group of which Stephen is such an outstanding example, we might ask ourselves how such a talent could be explained? Generally speaking normal children do not develop an advanced drawing skill until they have matured, although a few exceptional prodigies have been noted such as Millais and Toulouse-Lautrec. The ability to perceive and depict things as seen from one viewpoint, an approach sometimes described as 'photographic realism', develops only quite late in children of average ability.

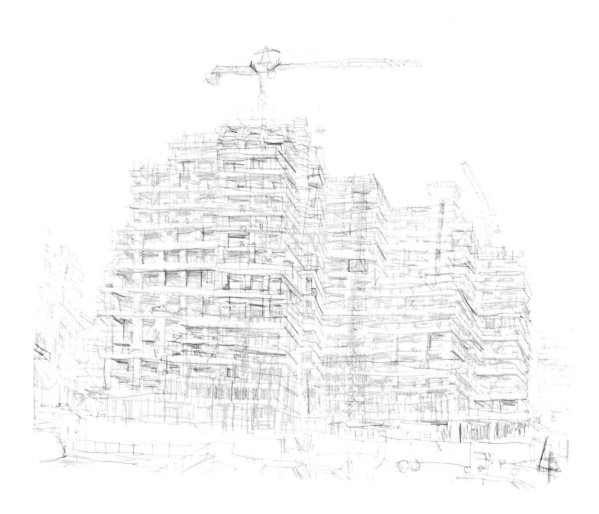

How, then, can a mentally handicapped child of thirteen years of age produce, after brief inspection, remarkably detailed representations of street scenes and façades which would be well beyond the skill of most of us?

One explanation which has been put forward, rests on the observation that normal children tend to pass through a stage in the development of drawing when they represent objects and scenes not realistically, but symbolically. By this is meant the tendency children show at a certain age to depict what they think of or are reminded of as well as what they can actually see from where they are standing. Why children do this and under what circumstances is a matter still in dispute. However, autistic artists like Stephen do not seem to go through this stage, but instead represent objects and scenes from one perspective just as if they were intelligent mature artists instead of immature and mentally handicapped children. How does this happen? How can it be explained? One ingenious solution that has been suggested is that this is not so much a gift as a failure to be able to symbolize or imagine, perhaps because of the autistic child's tendency to what has been called 'pathological concreteness', or lack of ability to construct or infer or think. In consequence, the child draws what he sees and not what other children think about, imagine or remember from previous sightings of the same scene.

This kind of explanation makes a strong appeal and might be a good one if nearly all autistic children were good artists. However, we know that less than ten per cent of autistic children are gifted and of these only a proportion are artists, so we still have to find a reason why the gift is given to one child and not another among the group of autistic children. Some recent work has suggested that the source of the artistic skill found in such artists as Stephen Wiltshire lies more in a facility for encoding visual images into motor hand movements to produce outline drawings rather than in an outstanding visual memory alone. This observation, which was based on experimental work, does not necessarily deny a capacity in gifted handicapped artists for constructive imagination.

Thus, although some advances have been made in recent years in attempting to identify, describe and investigate the skills of such otherwise handicapped people, we are still some way from giving a fully adequate explanation for their surprising gifts. Perhaps the best suggestion which has been put forward recently has been that these gifts emerge in a manner not dissimilar from the way in which speech is acquired by normal children. What happens in the case of speech is that neuro-muscular developments take place in infants and young

children which enable them to speak the language of their parents through a process which depends as much on maturation as it does on the child's imitation of parental speech. It has been conjectured that what happens in the case of some autistic artists is that instead of speech developing normally it is retarded, but other associative processes may be favoured and their development advanced. Such accidental and novel neural pathways as may develop in these circumstances may give rise to the unique intelligence-independent talents found in such cases as Stephen's. The new development may replace the normal development of speech. Such an instance may explain the clinical history of another autistic artist called Nadia, who had an outstanding artistic gift but is said to have drawn less, or lost her skill since she began to develop more advanced language as she grew older.

Such a view is, of course, speculative and whatever the ultimate explanation of this phenomenon may turn out to be, the drawings will certainly give a great deal of pleasure to many viewers just as they also give great pleasure to Stephen as he becomes involved in his work. Our pleasure as viewers seems to this writer to be a compound of two forms of appreciation, one the natural pleasure which well-executed sketches inevitably give us and another the satisfaction of knowing that someone whom we might reasonably regard as severely disadvantaged is, in at least one respect, our superior.

It might be asked whether knowledge of the occurence of unusual talents among the mentally handicapped can teach us anything concerning the education of other mentally disadvantaged students. The answer is unfortunately no. At present no studies of the way in which such talents develop from early infancy have yet been attempted, whether concerning art, music or calendrical calculation. As far as is known, the gifts do not begin to appear until the age of six or a little later and mostly in boys rather than girls. However, it must be said that work in this area has only begun recently and a great deal remains to be done. It is fortunate, none the less, that our ignorance of the underlying psychological processes does not stand in the way of our enjoyment of Stephen Wiltshire's drawings.

DRAWINGS

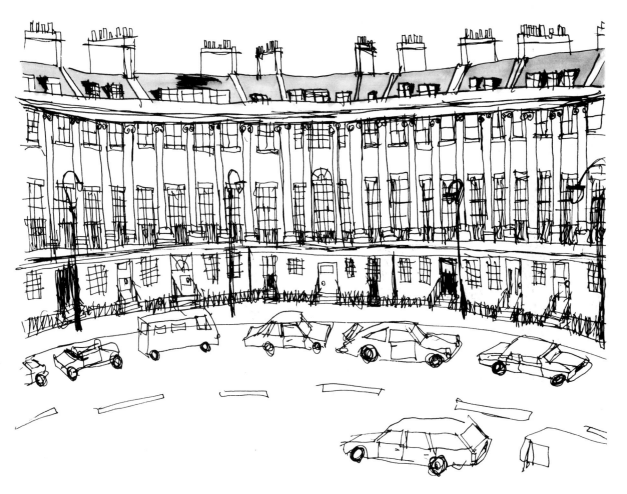

Royal Crescent, Bath

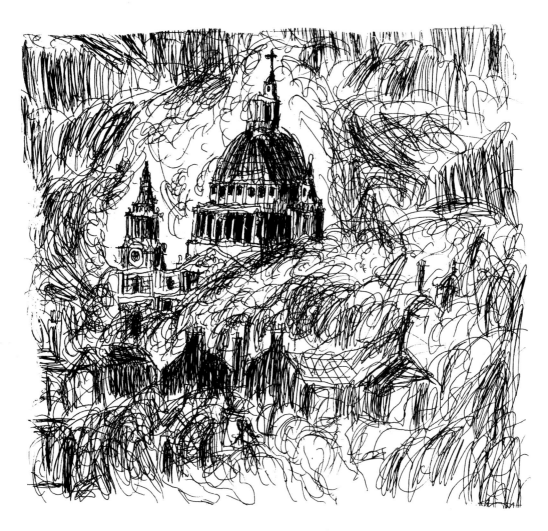

St Paul's Cathedral

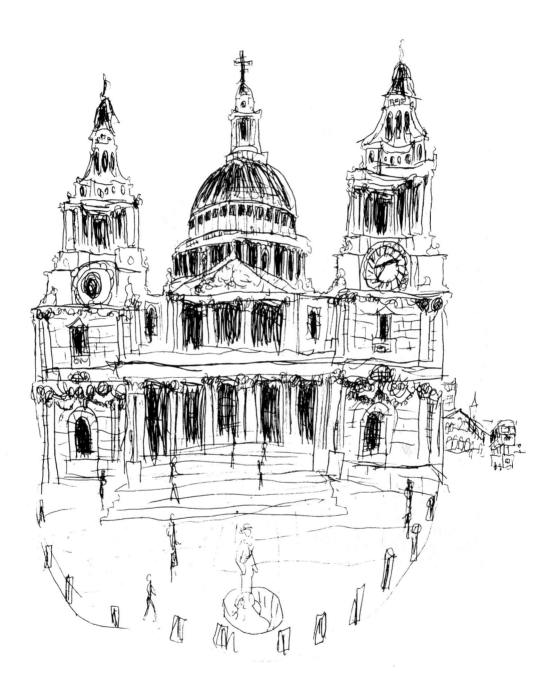

St Paul's Cathedral

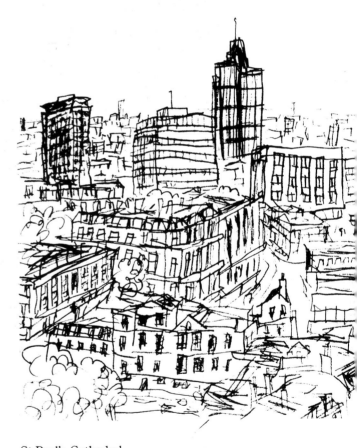

St Paul's Cathedral

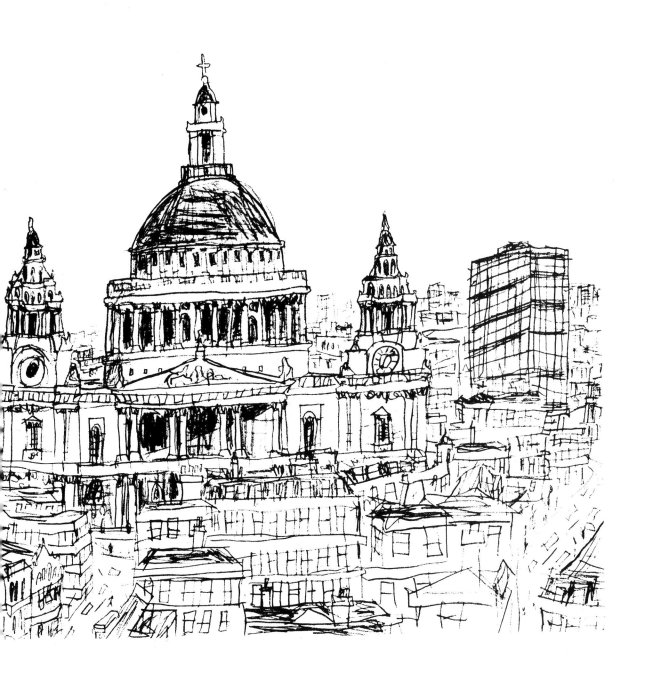

Venice

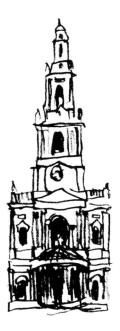

St Mary le Strand

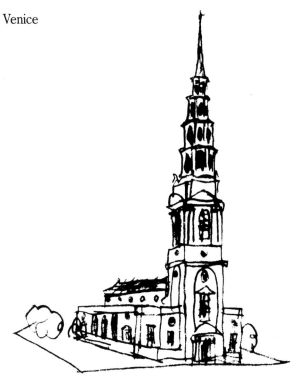

St Brides

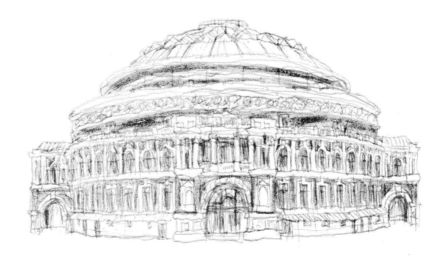

The Royal Albert Hall

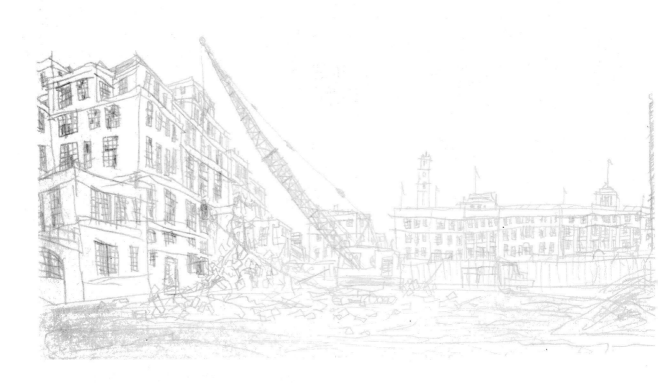

The crane is knocking down a building by the river

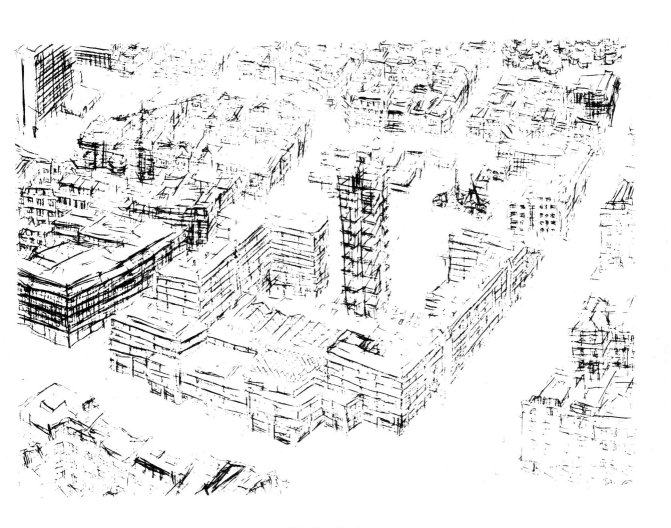

City Fire Station

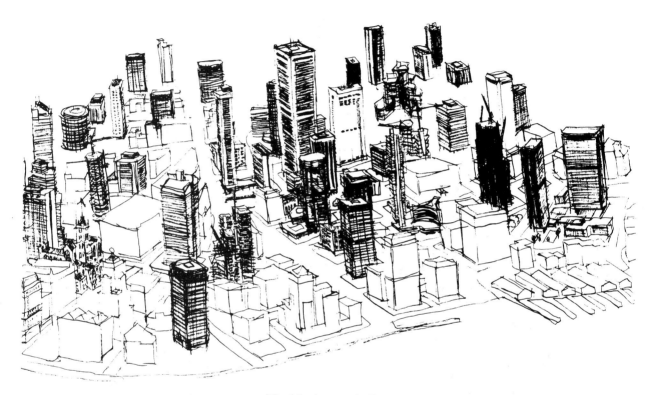

The Manhattan skyline

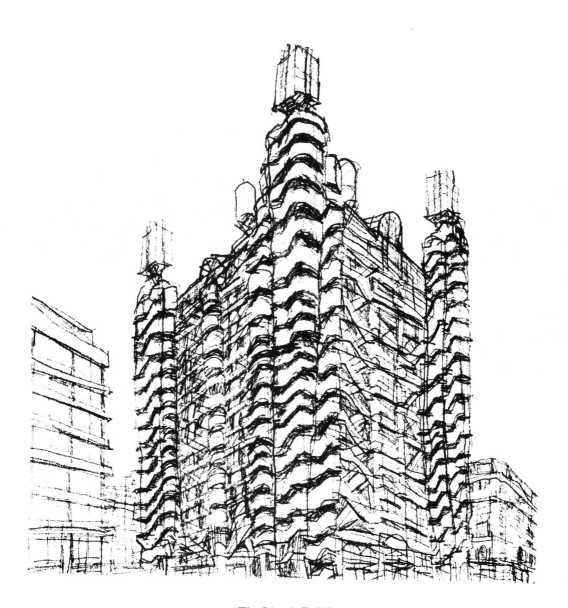

The Lloyds Building

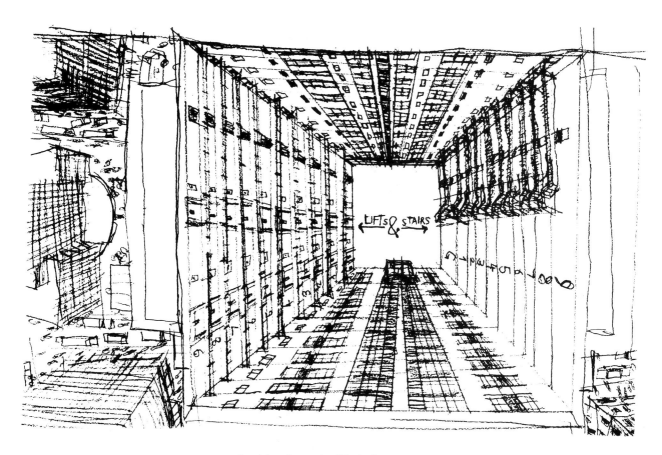

Looking down the lift shaft and stairs

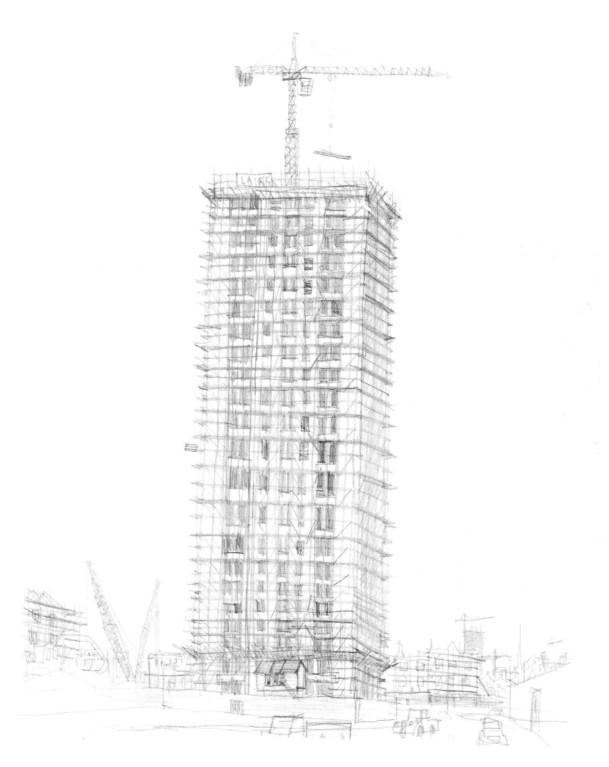

Building a tower block

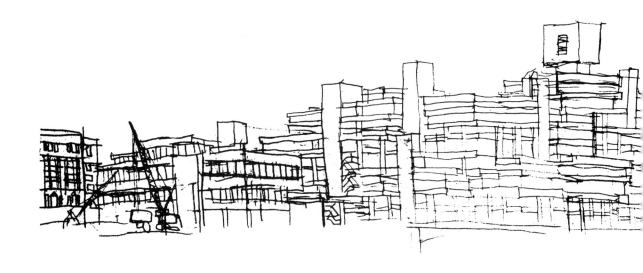

Flats on the river Thames near St. Katherine's Dock

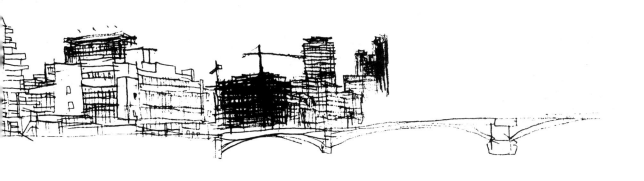

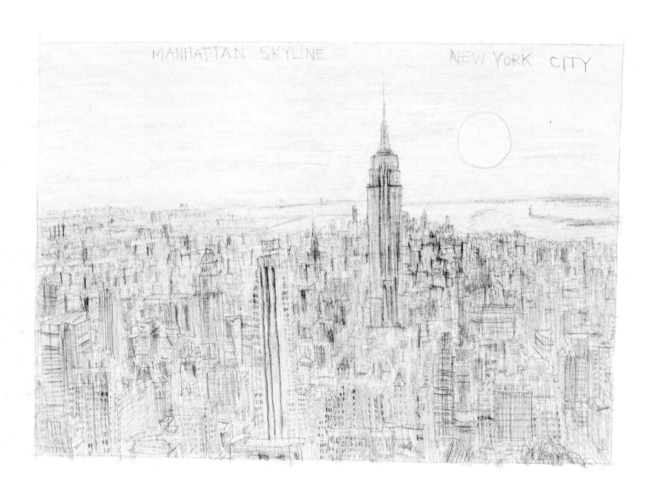

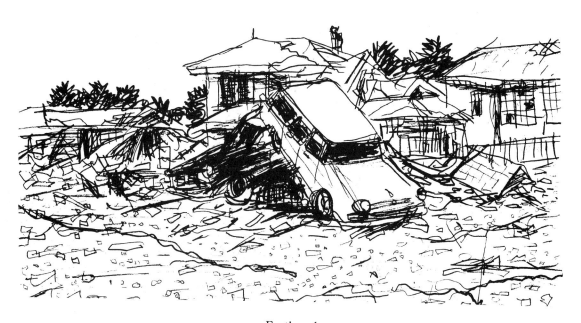

Earthquake
The earth gets shaken up, everything collapses

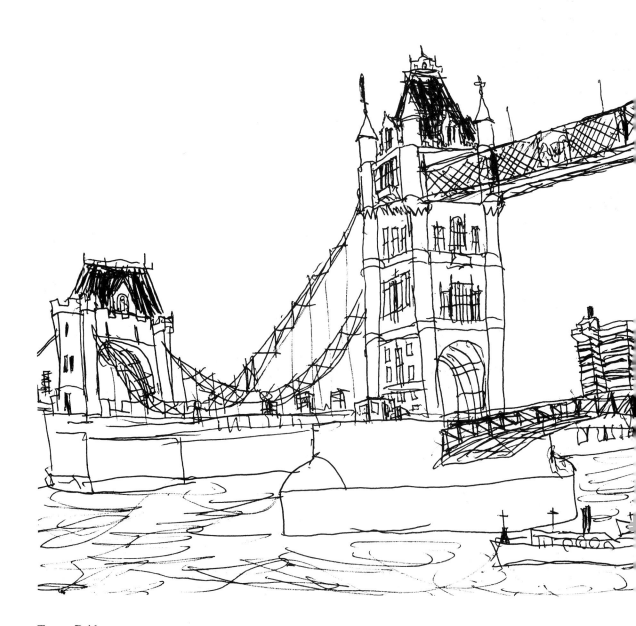

Tower Bridge

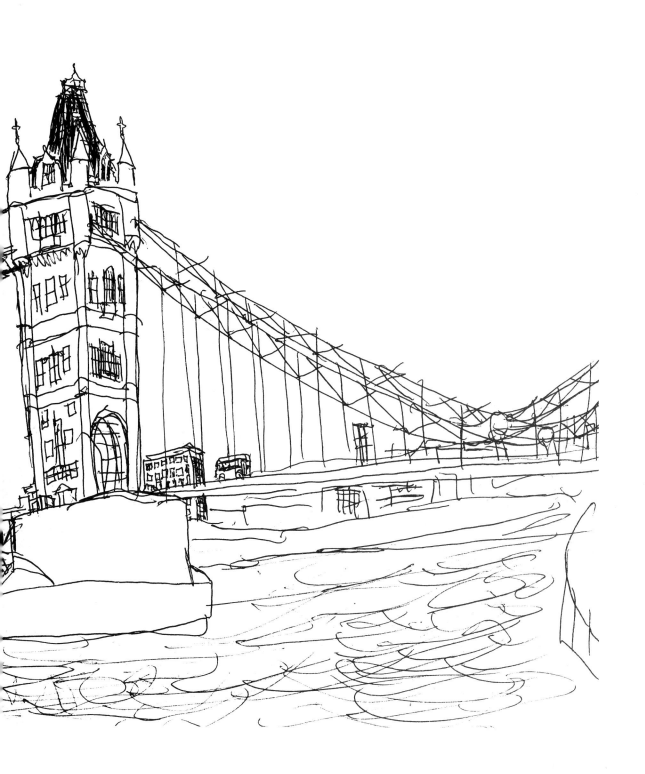

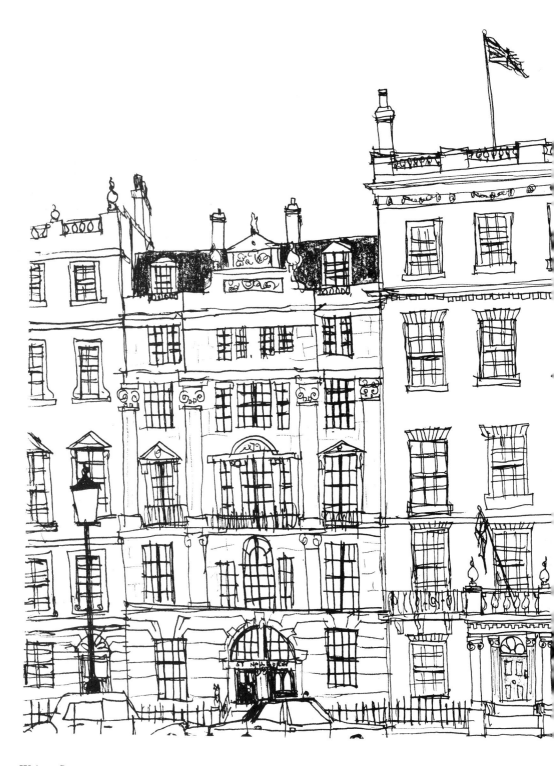

Walton Street

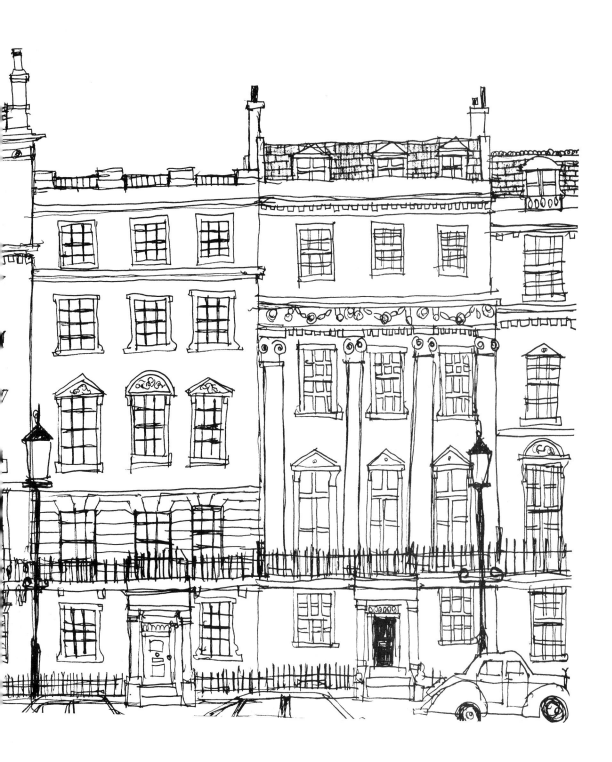

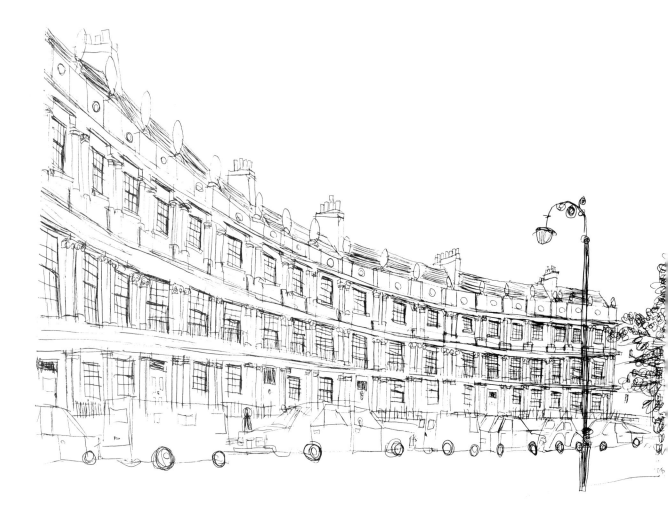

The Circus, Bath

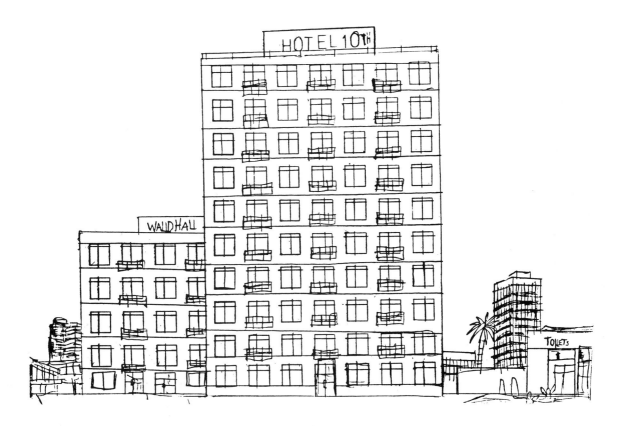

American Hotel

the Natural History

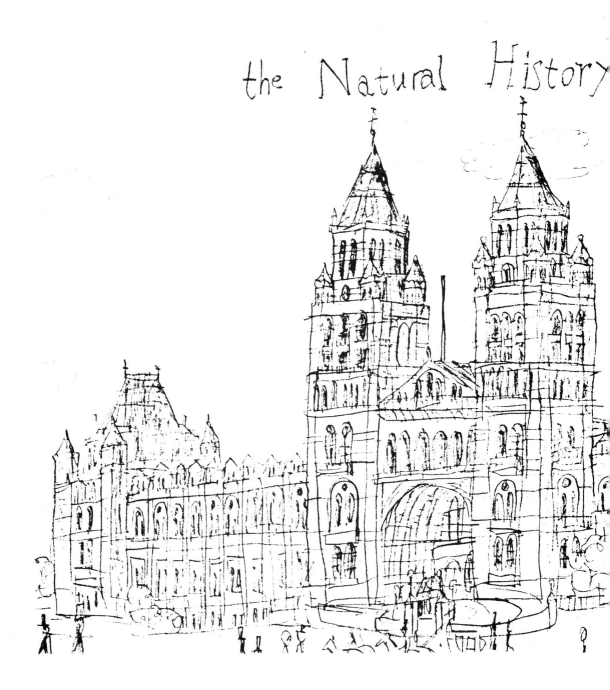

Museum By Stephen

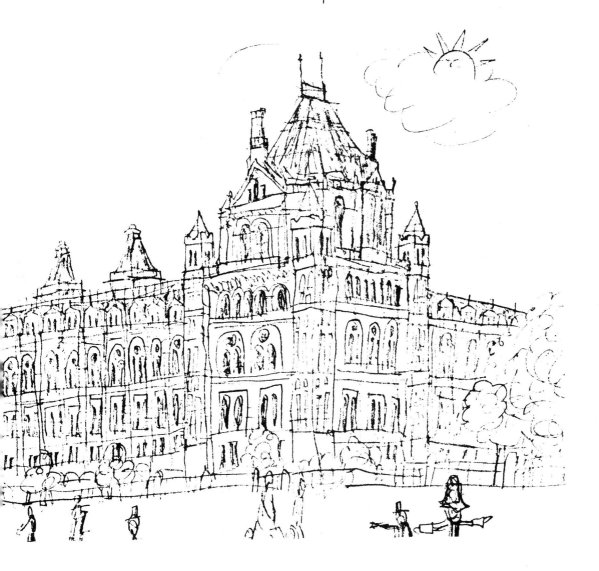

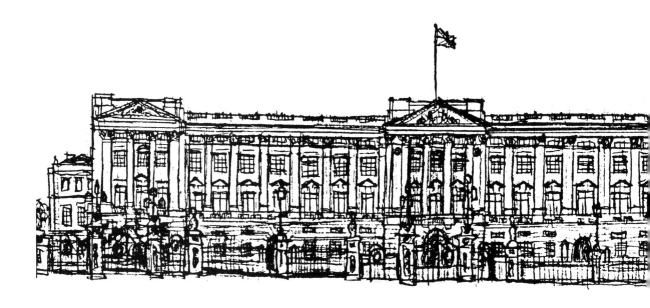

Buckingham Palace

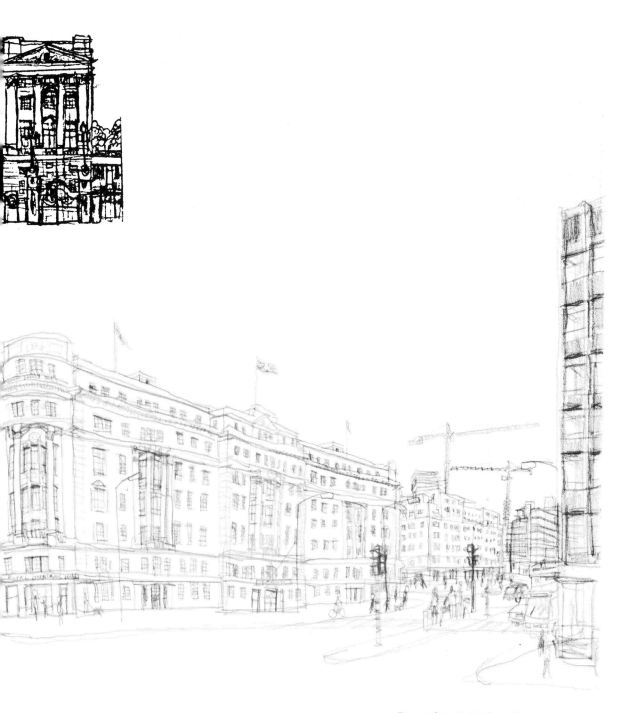

Royal City Palladium, London

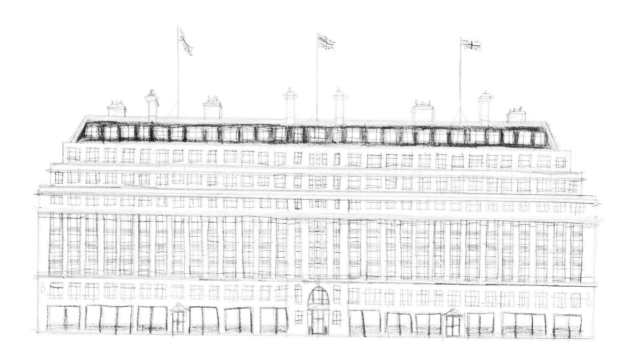

County Hall: detail

A LONDON ALPHABET

Stephen drew the 'London Alphabet' when he was
ten years old. It is one of his first examples of a
sustained, thematic group of drawings.

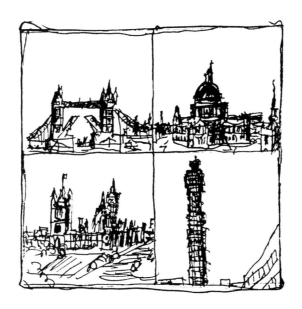

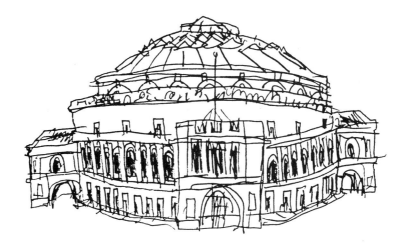

A *is for Albert Hall*

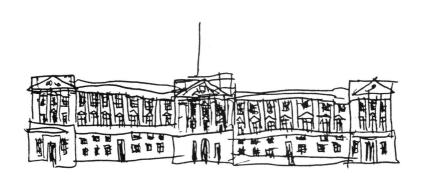

B *is for Buckingham Palace*

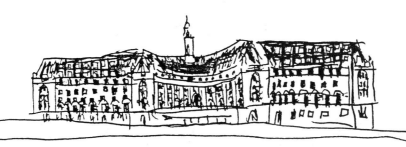

C *is for County Hall*

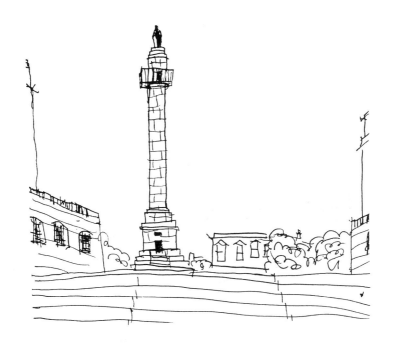

D *is for Duke of York Steps*

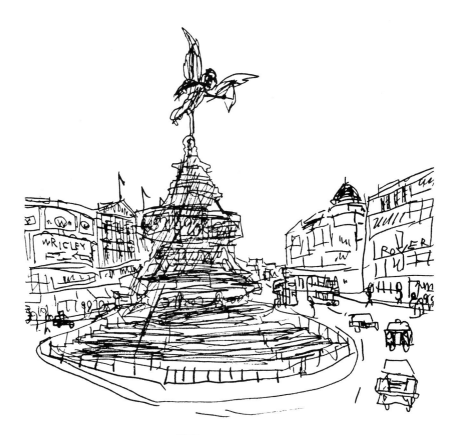

E *is for Eros*

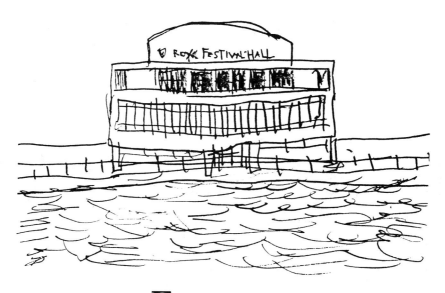

F *is for Festival Hall*

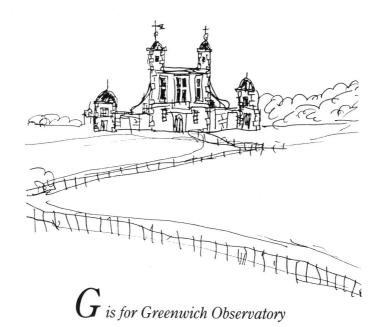

G is for Greenwich Observatory

H is for Houses of Parliament

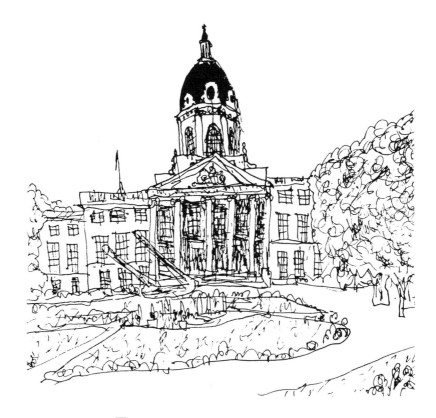

I *is for Imperial War Museum*

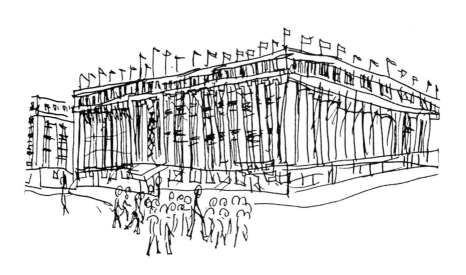

J *is for January Sales*

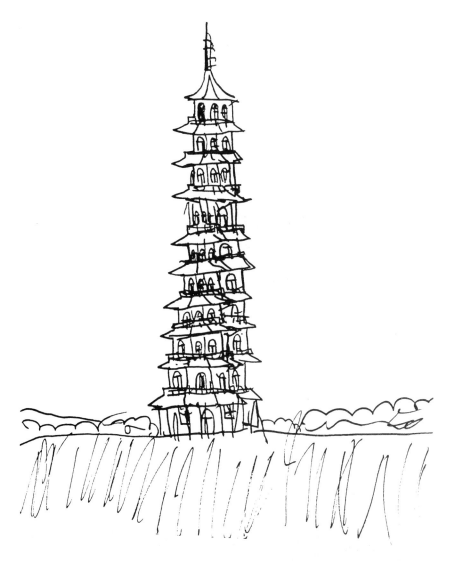

K *is for Kew Gardens*

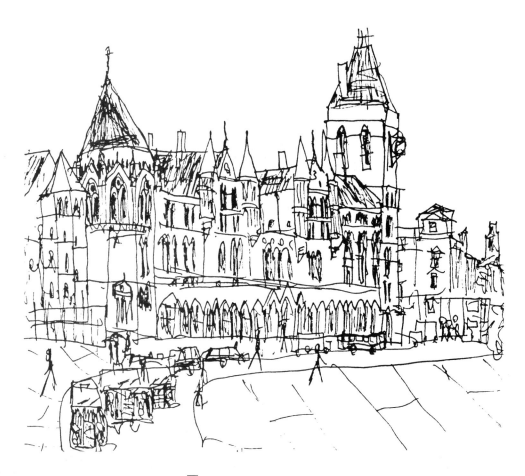

L *is for Law Courts*

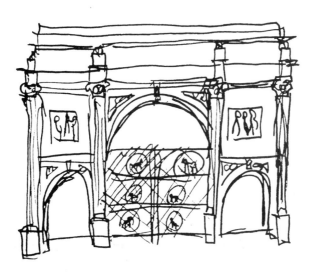

M *is for Marble Arch*

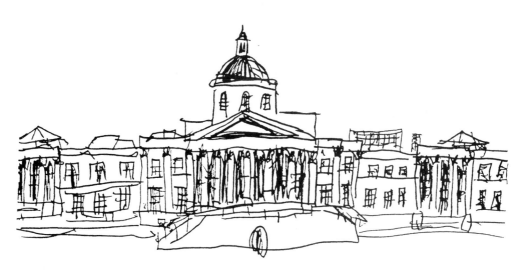

N *is for National Gallery*

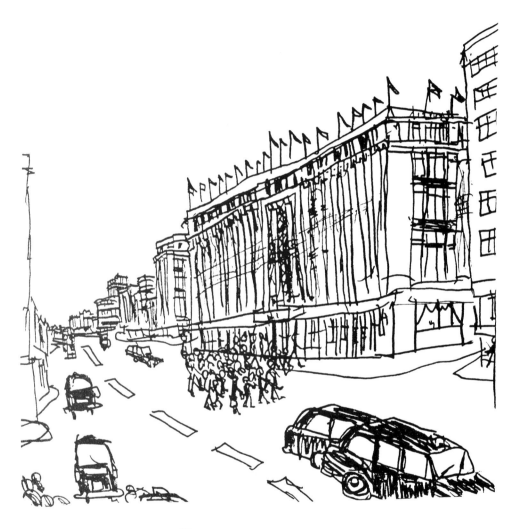

O is for Oxford Street

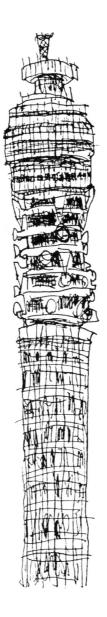

P *is for Post Office Tower*

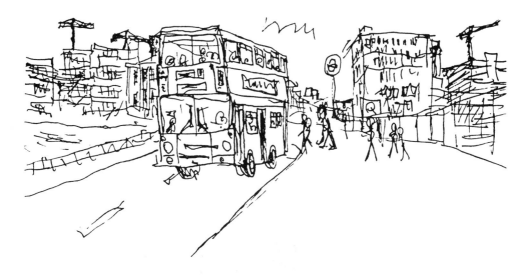

Q *is for queue for a bus*

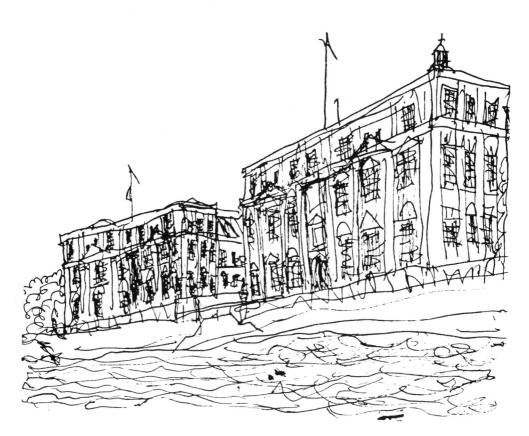

R *is for Royal Naval College*

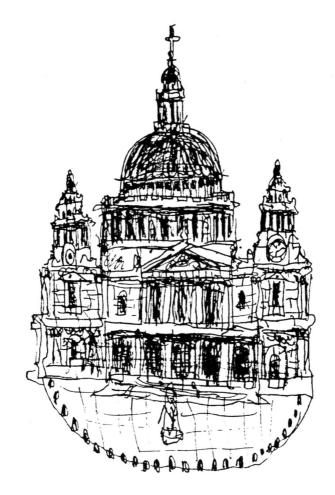

S *is for St Paul's Cathedral*

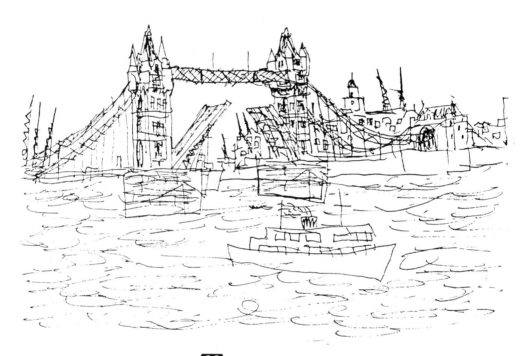

T *is for Tower Bridge*

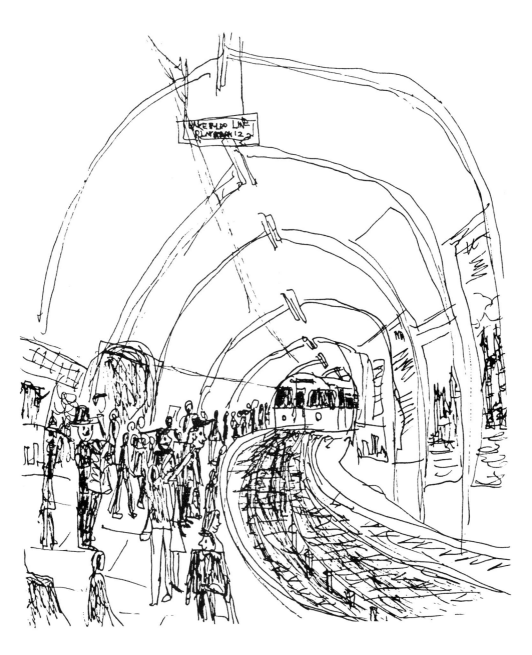

U *is for Underground Train*

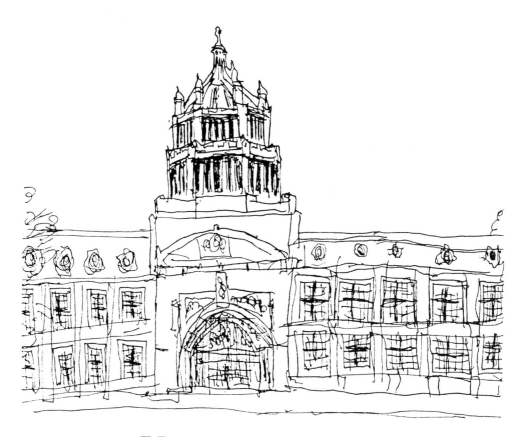

V is for Victoria and Albert Museum

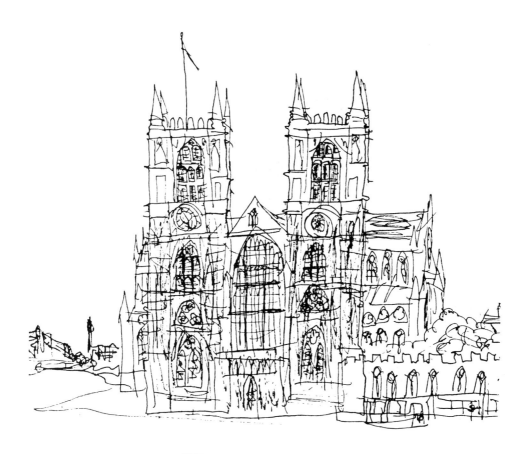

W *is for Westminster Abbey*

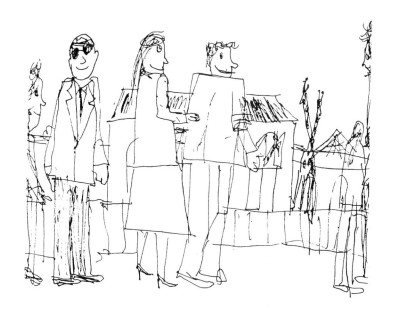

an e X *citing day*

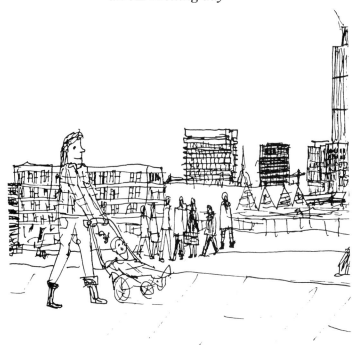

for some Y *oung people*

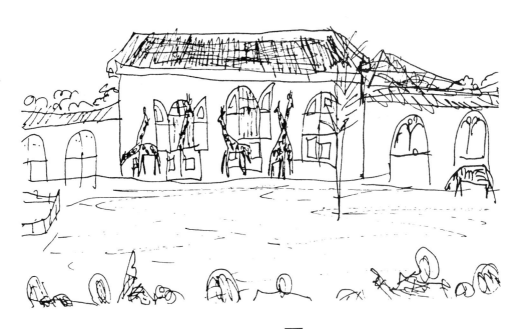

at London Z*oo*

A London Alphabet

HMS

The End

18
19
20
21
22
24
253
265
277
289
301
313
325
337
349
361
373
385
397
409